RELAX & RETREAT COLORING BOOK

SIMPLY CIRCULAR
Christmas Designs

31 Images to Adorn with Color

Racehorse Publishing

Racehorse Publishing books may be purchased in bulk at special discounts for sales promotion, corporate gifts, fund-raising, or educational purposes. Special editions can also be created to specifications. For details, contact the Special Sales Department, Skyhorse Publishing, 307 West 36th Street, 11th Floor, New York, NY 10018 or info@skyhorsepublishing.com.

Racehorse Publishing™ is a pending trademark of Skyhorse Publishing, Inc.®, a Delaware corporation.

Visit our website at www.skyhorsepublishing.com.

10 9 8 7 6 5 4 3 2 1

Cover artwork credit: Shutterstock/Shvaista

ISBN: 978-1-944686-91-8

Printed in the United States of America

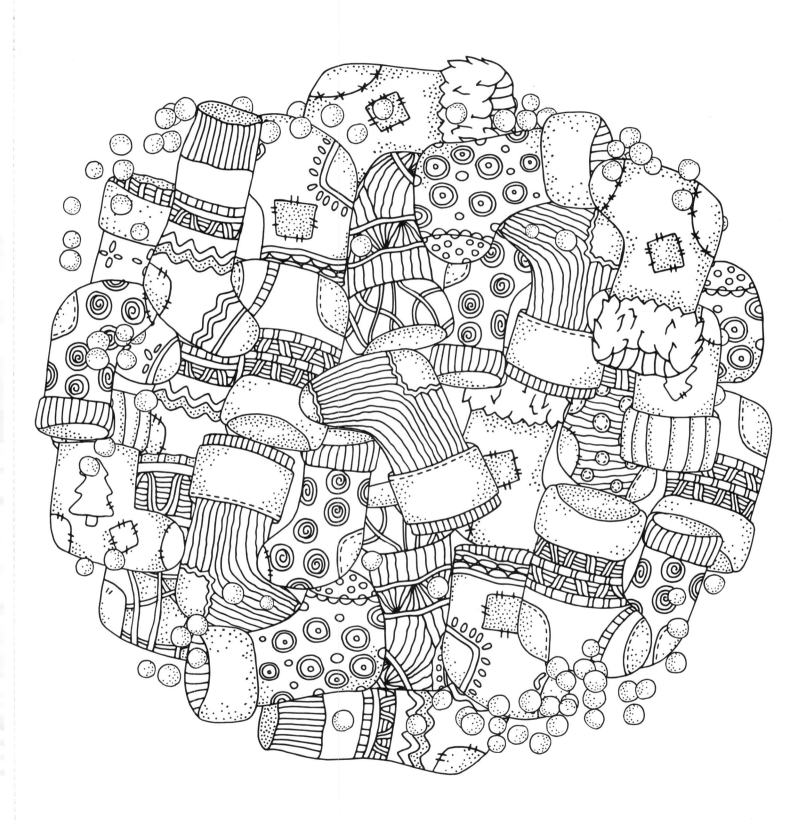

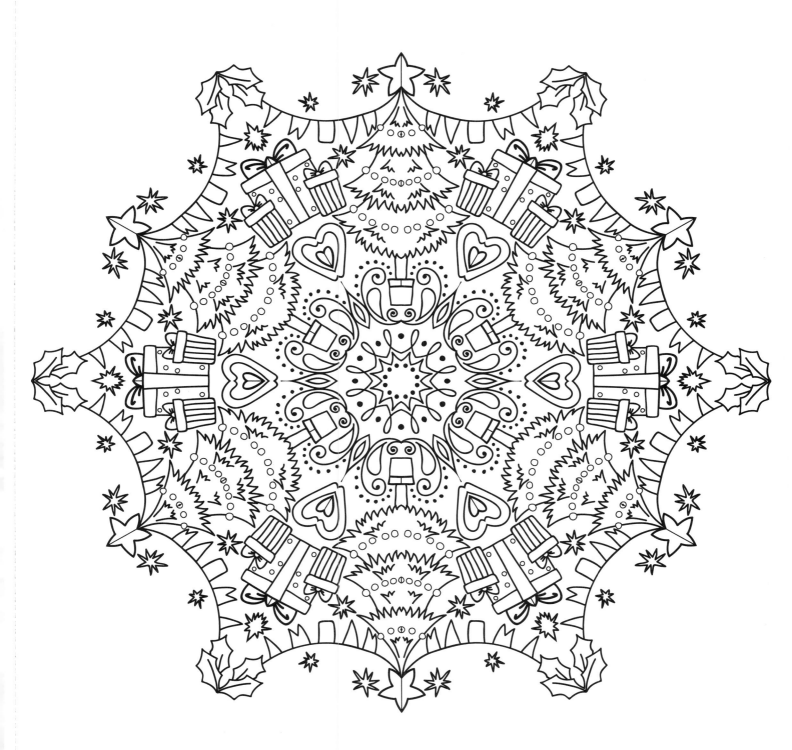

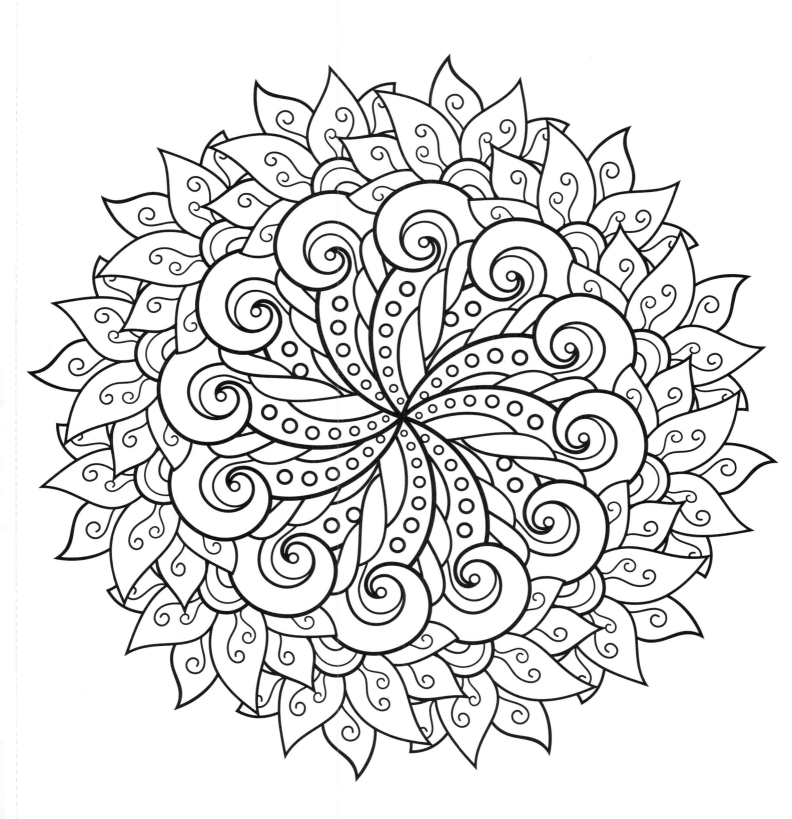

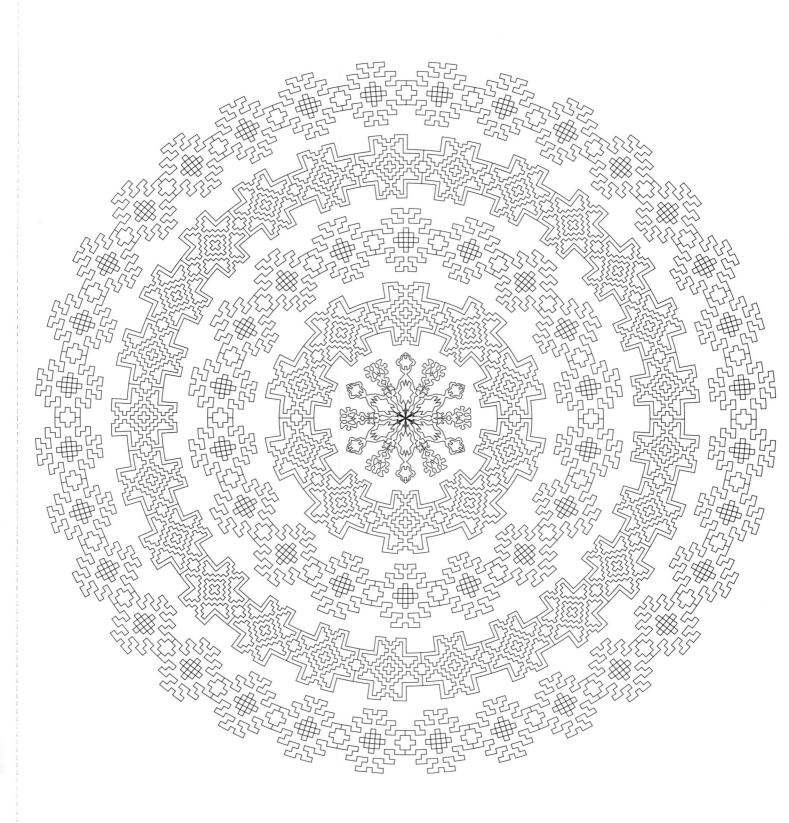

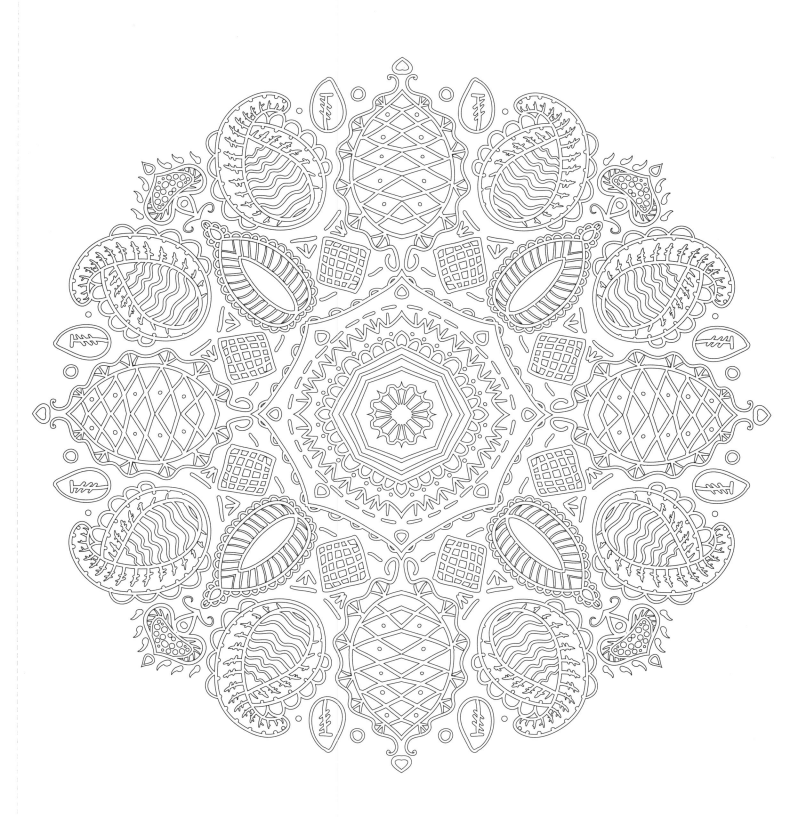

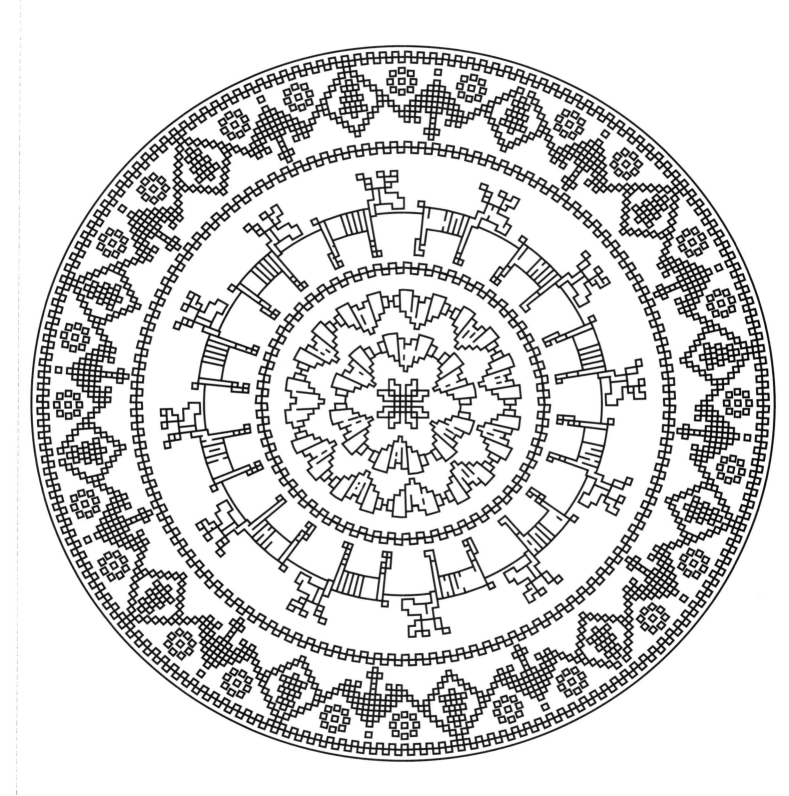

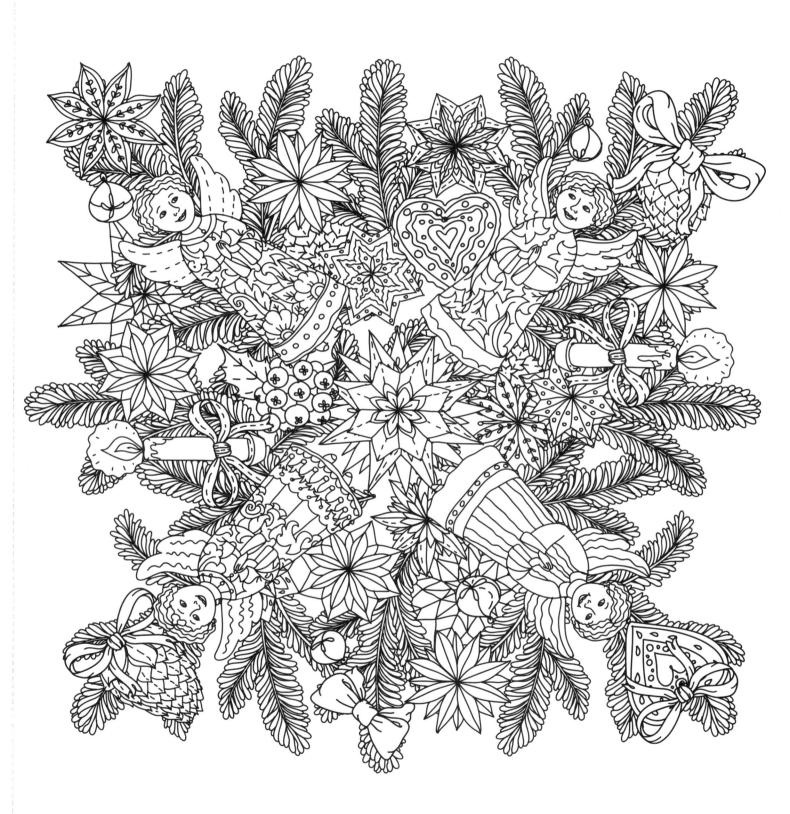

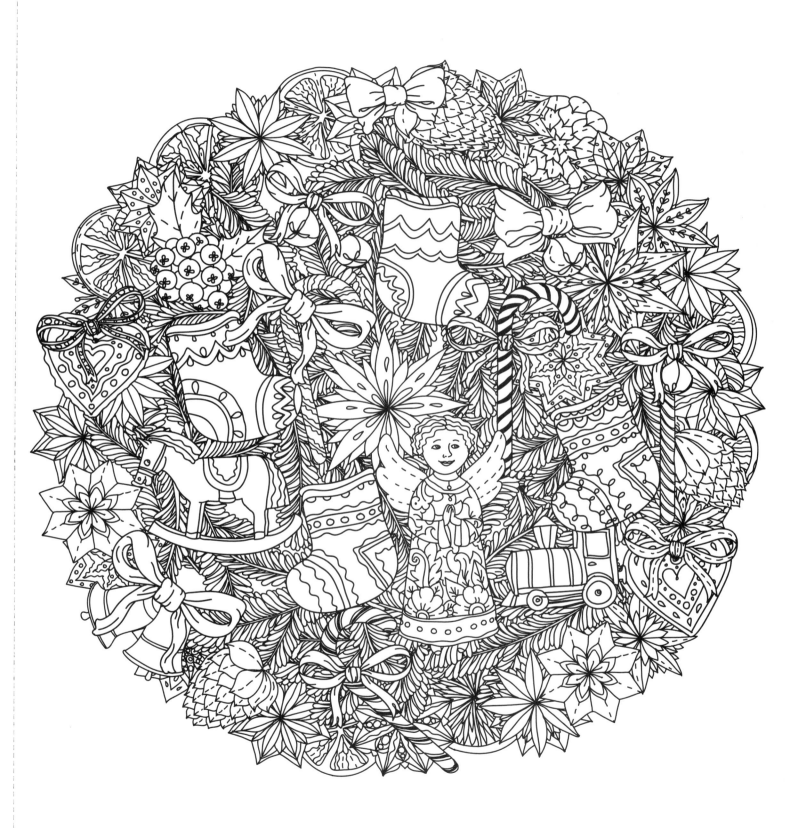

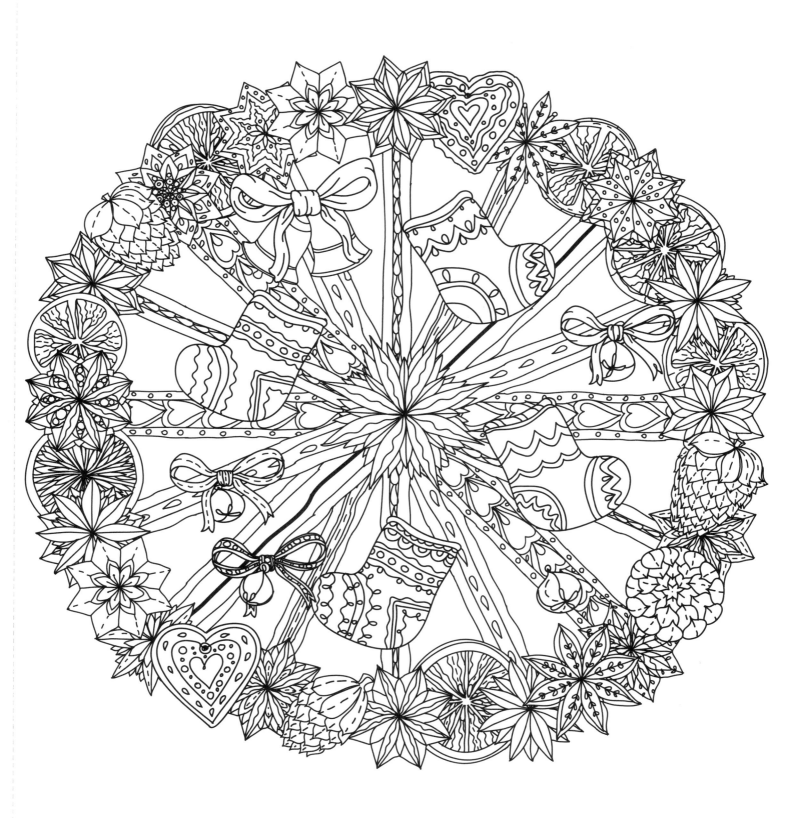

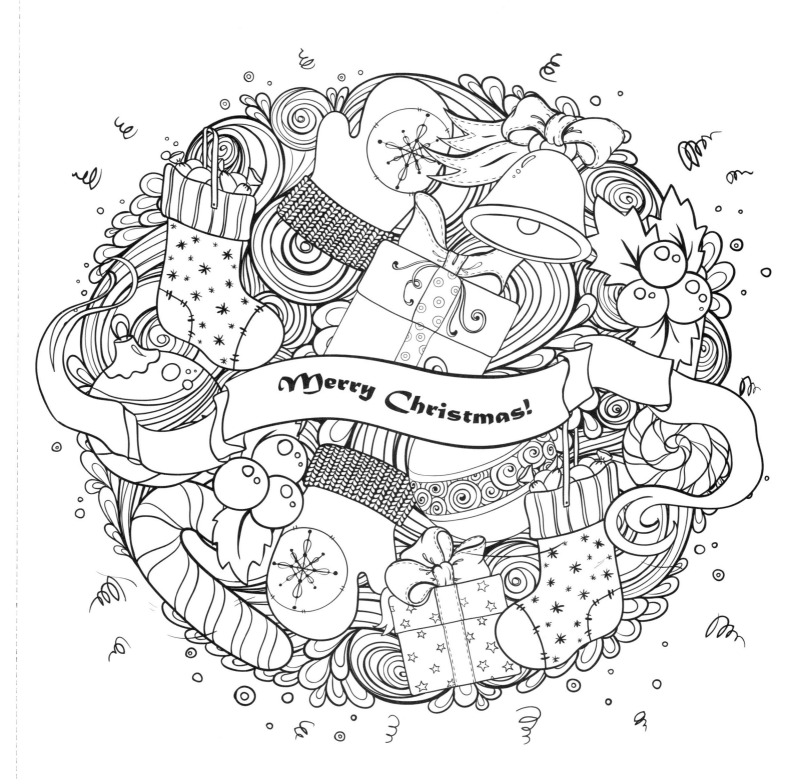

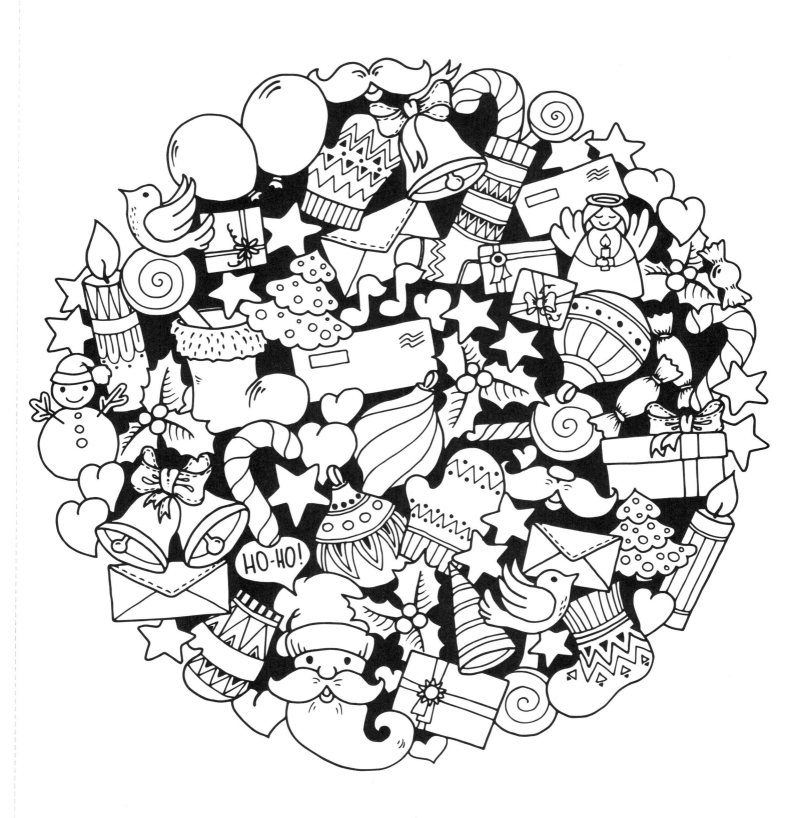

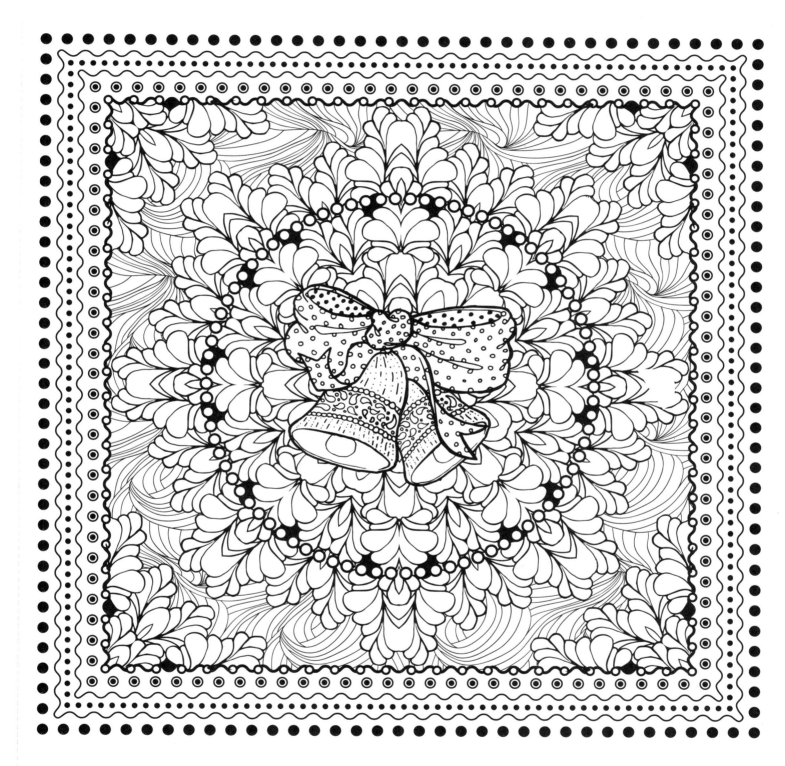

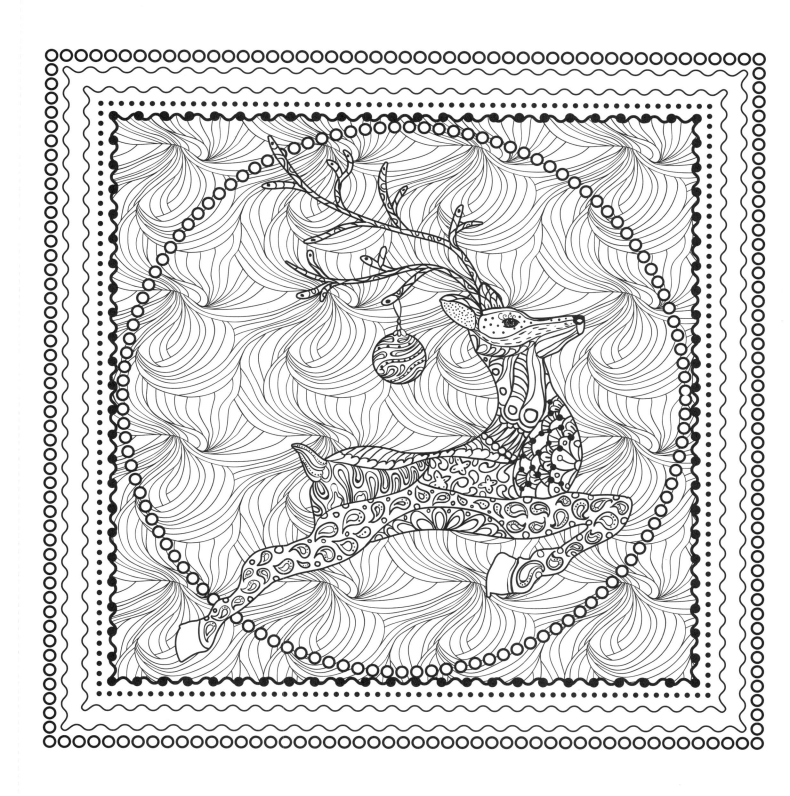

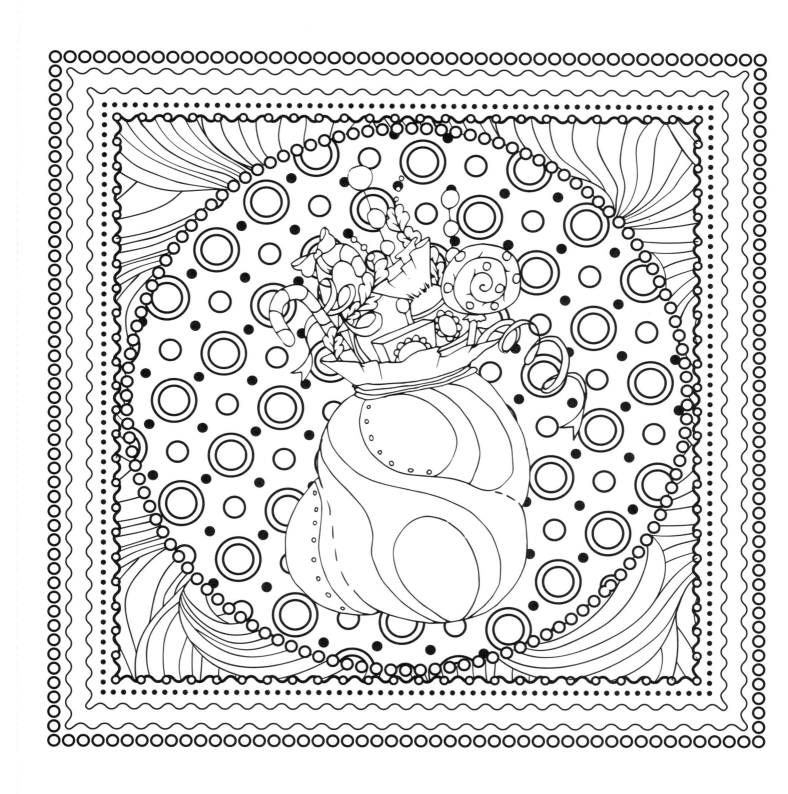

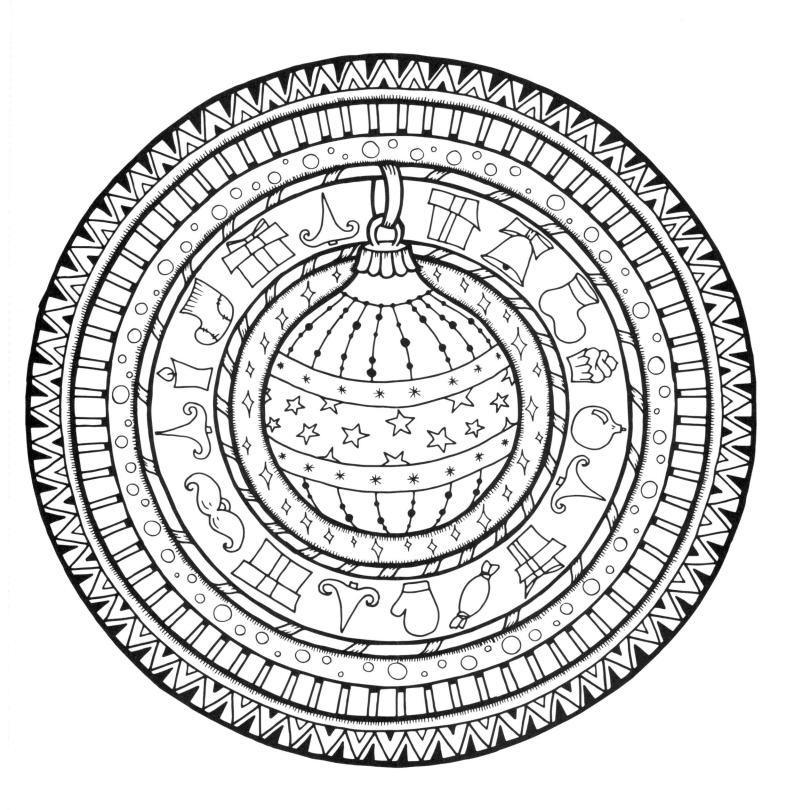